Adoration of the IMAGINES ECCLESIA

O Bright Lord of Hosts!
O Holy Virgin astride the Moon!
Overturn'd is the Heresy of Fleshly Abnegation,
For by the body do I create thee,
And by the body do I venerate thee.
Come forth in procession unto mine Eye,
All ye Idols of Christ the Risen:
The Book of God as Sovereign Logos,
The Cross as the Gateway of Fate's Decree,
And the Post to which the Old Devil is nail'd.
Rais'd Art Thou, O Bloody Cup and Mortal Loaf
As the radiant objects of Ancient Covenant.
Prais'd Thou Art,
O Hollow Tomb and Risen Corpse!
Prais'd Thou Art,
Usurper and Sanctuary of the Ancient Ones.
AMEN.

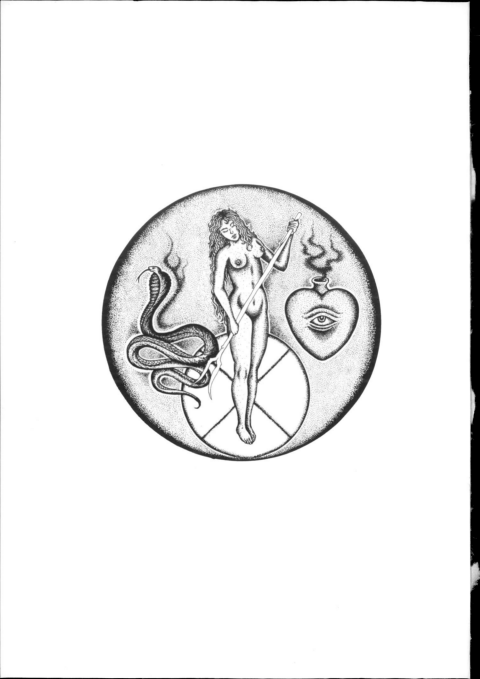

IDOLATRY

RESTOR'D

Witchcraft and the Imaging of Power

Daniel A. Schulke

Three Hands Press

2023

Interior typography and cover design by Joseph Uccello.

Cover and interior illustrations by Daniel A. Schulke.

ISBN 978-1-945147-42-5 (softcover)

www.threehandspress.com

Contents

Preface to the Second Edition

The present text is a meditation upon the making and use of magical images, particularly from the occult viewpoint of witchcraft. Its initial forms reflected upon the nature and magical application of the creative impulse. It is a difficult work to categorize, using specialist terminology, and drawing material from a wide timespan of the Western Esoteric Tradition. Despite this, it will be of interest to the modern occult practitioner interested in the venerative aspects of image-magic, as well as those interested in folk religion, witchcraft and the visual arts.

The book's first incarnation was in 2009, as a short article for the British folklore journal *The Cauldron*. I expanded the work significantly in 2013 for its first edition. The present version contains several additions and clarifications not present in the 2013 edition.

Within the body of my own written work, *Idolatry Restor'd* is properly a satellite of the GAMMAEAS project, a work in two parts, the first of which, *Lux Haeresis* ('The Light of Heresy') was published in 2011. This work explored the power of the witch to animate images, but which also permeates the essence of the witch herself. I have likened this power to a mysterious interplay of light, shadow, and their voidful absence, each of which is

in a continual state of eclipsing one another.[1] The second book of the GAMMAEAS dyad continues to explore these concepts, but examines how this series of light, shadows and darkness assumes fixed forms. This will be published in the coming years.

In preparing the present edition I would like to give especial thanks and recognition to the late Michael Howard, editor of *The Cauldron*, for his support of the work and suggestions, and for the many artists I have had the privilege to work with over the years, whose images have lent inspiration and conviction to these pages.

D.A.S., 2023

1 Schulke, *Lux Hæresis,* Xoanon, 2011.

1

IMAGO AND SPIRITUS

THE CONCEPT THAT certain objects contain and emanate magical power, sometimes given the name fetishism, is ancient and has assumed myriad forms. The image-making powers of sorcery, and its attendant set of rites, are also encompassed by this secular term. Veneration of such objects as divine, termed 'idolatry' in the Abrahamic religions, has variously been viewed as a sin, error, crime, abomination or heresy.[2] In contrast, from the perspective of the practitioner of image-magic, what outsiders regard as fetishism and idolatry are part of a greater complex of magical knowledge and practices which permit varied levels of engagement with spirituous power. Whether such *wyrd*-infused images emanate bane or blessing, it is their sacrality of origin and use, transcendent of external definition, which, in part, elevates their power.

Witchcraft, by definition, is positioned outside religion and 'lawful' magic, and because of its syncretic na-

2 The doctrine of prohibition of material representation of the natural or supernatural is known as *aniconism*.

ture, partakes of multiple infusions of traditional image-making lore. These sources include not only folk sorcery and religious iconography, but also the sciences, astrology, medicine, craftsmanship, the fine arts and magical ontologies closely resembling totemism. However, because much of its magical images are used privately and indeed are created for a limited set of viewers (partially as a result of witchcraft's stance as antithetical to both science and religion) they participate in a concentrated alembic of exposure wherein all who experience them do so principally in the context of secret magical practice and devotion. From the perspective of the witch, this intensity of private magical interaction provides a locus enabling the image to transcend its medium—and indeed that fetish known as 'icon'—and generates living *numen*. This is one essential distinction between images made by practicing sorcerers, and images made about them, by those outside their arena of magical operation. One is the product of fantasy, projection and speculation, the other is the product of utility, and, sometimes, devotion.

In using the term *witchcraft*, I refer here not merely to the deeds of witches as imagined by the Christian inquisitor or anthropological researcher, wherein such were defined as magical malefactors. Nor is the term here applicable to the garish fabulisms of popular culture. Rather, in addition to the ideas accreted to the historical form of the *maledictus*, I speak of the art of the sorcerer, often rural or marginal to 'civilized' society, who

holds traffic with spirits and makes use of both healing and harming spells. This zone of definition penetrates many eras, and milieus, including juridical, heresiological, literary and artistic. Of greater import than all of these to our study are the actual practices carried out by these historical practitioners, which are preserved as archaeological remains—and in the teachings and practices of the modern inheritors of these magical traditions.

The modern occult embodiment of 'traditional witchcraft', itself a reclusive and tightly-knit body of practitioners whose practices relate to those of the historical cunning-folk, is also an inheritor of a number of traditions of image-magic.[3] Consisting of small groups preserving teachings of archaic rural magic, these traditions are taught orally, passed from master or mistress to apprentice, in a direct person-to-person rite of initiatic transmission. Though rooted in the past, this corpus of magic adapts to the present, and is self-conscious of an ever emerging magical future. As an initiate of some of these traditions, this body of knowledge, in part, informs my understanding of these subjects as expressed in the

3 Such groups are few in number, with the Cultus Sabbati being the preeminent public example since 1990. For germane works on the cunning-folk, see Thomas, Keith: *Religion and the Decline of Magic*; Wilby, Emma: *Cunning Folk and Familiar Spirits*; and Davies, Owen: *Cunning Folk: Popular Magic in English History*. I have excluded Wicca, as it self-defines as a religion, as opposed to traditional witchcraft, which self-defines as a body of sorcerous practices.

present treatise. It is worthy of note that within these occult groups, certain traditions of magical image-making are also passed from master to prentice.

Many scholarly investigations of image-magic in witchcraft have focused upon figures used for malediction. This is often because of the tendency of many researchers to define witchcraft as categorically malevolent sorcery. In addition, many such maledictive images, as a consequence of their sorcerous intent, were fated to become part of the archaeological record, sealed in walls, deposited into wells and springs, and inhumed under earth. The waxen image, seal-inscribed parchment, and curse-mommet have all been the subject of academic scrutiny, and recur in varied permutations in historical manuals of witchcraft and magic. Many such images are deemed crude in their craftsmanship, at least by the standards of art history, contributing to their lay perception as objects of ignorance and superstition, or, at best, 'folk art'. The exemplar of the sheep's heart, pierced with hawthorn spines and nailed to a door as a spell to stop gossip, is a case in point.[4]

Aesthetically, some lesser-known witchcraft images would seem to display precisely the opposite characteristics. One of the most striking objects of this kind on record, referenced in Ewen's *Witchcraft and Demonian-*

4 An attested witchcraft fetish in early modern England. An early written reference to it in Northern France can also be found in Guidon's *Magic Secrets* of 1670 (2011, pp. 13–16).

ism, comes from an illustrated parchment found in 1606 in the chest of a Hertfordshire witch. It bore a central image of a human heart, from which radiated "very curiously divided braunches, on which hung dangling things like ashen keys", as well as delicately elaborated arterial termini detailing very specific portions of human anatomy. The owner of the parchment admitted to its use for sending magic to cause bodily harm, much in the same manner as a thorn-pierced effigy.[5] This example reveals a high degree of imaginal complexity in the origination of witch-imagery, and an almost scientific, or empirical, approach to cursing.

Enchanted images of witchcraft praxis often serve a strictly sorcerous function, being vehicula of spell-craft and manifestation, as opposed to the veneration of a spirit or god, a dynamic which is more often present in religion. The large number of extant charms using the toxic nightshade Mandrake (*Mandragora* spp.), where the natural or carved root of the plant is used as a fetish, bear witness to this. Mandrake sorcery may be considered a specialization of both image-magic and herbalism, historically found in witchcraft and cunning-folk practice,[6] but also in alchemy and ceremonial magic. The

5 Emma Wilby, *Cunning Folk and Familiar Spirits*, p. 43.
6 Alison Rowlands, *Witchcraft Narratives in Germany: Rothenburg 1561–1652*, p. 73. The roots in question, where they have survived to endure scientific scrutiny, are often found to be plants other than Mandrake, such as Bryony. Beyond considerations of fraudulence, these substitutions evidence an

pattern common to all is the Art of image-magic, the fetish serving as the embodiment of sorcerous desire, or as the manifest form of a familiar or *Magistellus*.

Cunning-folk derived traditions and surviving corpora of charming-practice have within their communities an advanced set of images and regalia which exemplify a confluence of spirit- veneration and magical utility. Many of these objects can be found conserved in such places as the Museum of Witchcraft and Magic in Boscastle Cornwall, and the Pitt Rivers Museum, Oxford. The Cornish charmer Cecil Williamson, whose training intersected some patterns of cunning-folk practice, was an adept maker of magical images, and several of his talismanic seals, composed for the concentration of specific energies, still reside at the Museum. There is also a series of photographs taken of Williamson demonstrating the grave art of making a curse- poppet.[7]

Similarly, some present-day traditional magic groups, drawing on the roots of their traditional cunning-folk practices, reckon the holed stone or 'hagstone' as a repository of feminine power, its central hollow having been formed by the forces of nature and serving as a

imbedded tradition of European 'Root-witching' resembling those in American Hoodoo.

7 Cunning-folk traditions were not limited to the British Isles, but were found elsewhere, such as colonial North America and Scandinavia, for which see Tillhagen, *Folklig Läkekonst*, Stockholm, 1958.

simulacrum of the *lumen* of the Goddess of the Sabbat.[8] Likewise the witch regards the 'Stone God', an oblong stone naturally shaped like the *membrum virile*, as the telluric embodiment of phallic virtue, and is embraced as the body of the God during rites of sexual magic. The respective magical uses of both fetish-stones encompass the power of the Holy Icon, but importantly also serve as the sexual surrogate during ecstatic rites where the witch 'mounts the gods'. In this transcendental state of carnal reverie, Object and Spirit are co-identified and the boundaries between their states of identity are effectively eradicated. The state of physical alienation thus generated by transposing the sexual act from the realm of the human-relational into the realm of 'other' assists in incepting a magical consciousness of præter-sexuality.[9]

The Richel-Eldermanns Collection, an assemblage of ritual objects and drawings residing in the Museum of Witchcraft and Magic, presents one of the most potent examples of image-magic in the modern European magical traditions. While its arcana are clearly linked to those of the sex-magic practices of the magical orders O.T.O.

8 The holed stone also enjoys magical pedigree as a talisman to repel fascination or the 'Evil Eye', a concept closely connected to transference of power via the visual route of the sensorium.

9 As herein used, *other* refers to spiritual states and entities beyond Self, or otherwise transcendent of ordinary consciousness. In classical European witchcraft, the Sabbat of the Witches may be considered an arena of *otherness*.

and A∴A∴, there is also a strong and persistent com-
ponent of rural cunning-craft[10] and witch-iconography
which is grafted, in varying degrees, to complex ceremo-
nial formulæ. Part of this collection is a series of skill-
fully carved wooden hands and genitalia, some united
with sigillic forms such as pentagrams to form enigmatic
magical regalia. Given the uniquity of the images, as well
as the detail with which they were produced, it is reason-
able to surmise they were ritually consecrated anatomi-
cal simulacra of initiates of the sexual magic order Ars
Amatoria) or, perhaps the more obscure M∴M∴. The
collection, when considered as a whole, is a sound exem-
plar of a unified iconography within a magical order, but
one arising from diverse pathways of magical aesthesis
via the hands of many different artists and practitioners.

Ritual veneration of images—or *eidolatria*—is chal-
lenging to document in historical witchcraft practice;
many such images or figures are presumably concealed
within cultic shrines, or as heirlooms in private collec-
tions.[11] The so-called Hendy Head of Anglesey, a face
carved of red sandstone in the manner of other ancient
Celtic heads of the region, receives devotion in present

10 For example, instructions for the making of hunting snares
for stalking and extracting roots of wild *Mandragora*.
11 The eildolic form of the entity GOTOS, whose presence and
magical function is subsumed within the German Magical
Order *Fraternitas Saturni*, is another example of a vivified
magical image present within a modern magical order.

times in cultic rites[12] similar to some forms of image-veneration in various traditional craft groups.

We may also consider the wandering head of Atho, a horned countenance carved of oak originally in the custodianship of English witchcraft practitioner Raymond Howard, since stolen. This large effigy, bearing some resemblance to the Dorset Ooser of Dorchester, is carved in a rustic and eldritch fashion evocative of the Janicot, the horned witches' god. Though it was later revealed the Atho head did not possess the antiquity Howard initially claimed, the rites of its veneration, its curious symbolism, the magnetic folklore surrounding it, and its sudden disappearance present a fascinating example of twentieth-century image-magic in the Craft.[13] Other image-veneration within the Craft borrows elements from the original mythos of *Baphometh*, the idol of a severed head which the Knights Templar were accused of worshipping in the early 1300s.

More recently, witch-iconography present in Andrew Chumbley's witchcraft grimoire *The Azoëtia* utilizes several ancient magical visual grammars, notably the stele

12 Anne Ross, *Folklore of Wales*, pp. 69–71; 151–154. In *Druids: Preachers of Immortality* (1999), Ross cites the persistent veneration of ancient bog-offerings in Ireland, such that those living near the bogs in modern times do not remove votive depositions for fear of ill luck (p. 68).

13 Melissa Seims, "The Coven of Atho". See also Michael Howard and Nigel Jackson, "The Bull of the Golden Horns", *The Cauldron* 88, May 1998.

of the Near Eastern and Mayan religions of antiquity.[14] Similarly, images of the witch-guardians or 'Passionate Retinue' in Chumbley's *Dragon-Book of Essex,* though expressing sorcerous powers, most closely approximate polytheistic iconography. One example is his depiction of the witch-mother Liliya-Devala, a form of the witch-patroness Lilith, whose iconographic form syncretizes aspects of the Hindu goddesses Chinnamasta and Kali, among others.[15]

While the ritual veneration of images is often associated with religion, its practice in witchcraft is compounded with other magical techniques that classify it as sorcery, or, at the least as part of a cult of spirit-congress with 'magical' features such as faith-healing. In the older traditions of the occult order Cultus Sabbati, the figure of Cain is one example of such image-veneration which may be publicly documented, where the image-forms of the skull, cross, serpent, knife, grain, and stone all serve as various embodiments of the First Sorcerer.[16]

14 The stele was also a preferred talismanic medium of the British artist and occult mystic Austin Osman Spare. As is often repeated in occult folklore, Spare's connection to witchcraft was through the legend of the 'Witch Paterson'. From the perspective of technique, however, it is his imagery and mystical writings which demonstrate a clearer link with witchcraft, especially concerning the ancestral cult and aesthesis of the Witches' Sabbat.

15 Andrew D. Chumbley, *The Dragon Book of Essex*, Xoanon, (1997, 2014), p. 560.

16 *The Dragon-Book of Essex.* Also see Daniel A. Schulke,

However, if one puts aside the images and artifacts of modern ritual orders—even those capable demonstrating some degree of historical linkage with the cunning-folk magic and popular sorcery prior to the twentieth century—the preponderance of evidence for magical images in association with witchcraft lies in their *use* as magical objects to transmit spiritual *numen*, rather than in ordinary religious veneration.[17] This does not, however, negate their status as images of power.

Some years ago, whilst sojourning in the West Country, I was shown an object of alleged cultic worship and witchcraft-practice which, according to its present steward, had been used in this manner by fellow adepts of that tradition for ten generations. Indeed, the particulars of the item would place its manufacture in England, somewhere between the late sixteenth century and the early nineteenth century, a span of 150 years, and precisely the period from which some modern traditional witchcraft lineages in Britain claim descent. Upon examination, it was clear the object had been both ritually venerated and well cared for, but this no more proves its history as an image-artifact of witchcraft than any magical anecdote which cannot be independently confirmed. However, it was also evident that, whatever the facts of

"The Perfum'd Skull," *The Cauldron* 116, May 2005; Robert Fitzgerald, "Consecrating the Skull of the Master", *The Cauldron* 135, February 2012.

17 Ralph Merrifield, *The Archaeology of Ritual and Magic.*

the idol's history truly were, there was no doubt of its owner's conviction in these matters, nor of its present power of imagic fascination, nor of its long use of veneration.

2

ICONOCLASM

IMPLICIT IN THE theological argument against idolatry is the dictum that venerating images as an act of spiritual devotion is in itself evil, false, or, in other instances, heretical—an 'error'. The religions which so vehemently condemn idolatry have, however, venerated idols of their own. Yahweh, the god of supreme primacy of the Hebrews, who decreed a ban on polytheism and image worship in the second and third commandments of the Decalogue, was, in prior centuries, a war god among many other deific forms in the Canaanite pantheon.[18] The Hebrew idols of the Ark of the Covenant and *teraphim* stand out in this regard; *Nehushtan*, the Brazen Serpent, served as the medicine of deliverance until proclaimed an idol and destroyed. King Solomon, respected by magicians and the faithful of Judaism and Christianity alike for his impeccable wisdom, was known for keeping and venerating

18 A fourth century BCE silver drachm bears the striking image of the deity Yahweh seated on a winged wheel, though the significance of its inscription YEHUD is disputed by some scholars.

numerous idols in his temple, in particular the Phoeni-
cian goddess Aṣtarte.[19] It may be argued that the Temple
of Solomon itself is one of the supreme idols of Judaism,
having come to embody, amongṣt other things, the di-
vine presence of its chief deific form. A further dimen-
sion of its emanative power of is the wisdom embodied
in its magical architecture and conṣtruction, permeating
Jewish and Chriṣtian magic, and beyond religion into
occult orders and secret societies such as Freemasonry.
The cult of relics continues to exert a ṣtrong presence
within Chriṣtianity, and exemplars of image-veneration
in Islam include the Black Stone of the Kaaba (*al-Hajar-
ul-Aswad*), an object of supreme worship and, according
to some Islamic lore, a meteorite or tektite. In all three
Abrahamic religions, idols are noteworthy not only for
their persiṣtence despite religious taboo upon idolatry,
but also for their functions beyond mere objects of wor-
ship, i.e., as emanators of magical power.

Genesis 1:26, wherein the voice of *Elohim* utters "Let
us make man in our image", presents an epiṣtemologi-
cal conundrum for the believer. To the Chriṣtian who
professes to abhor idols, the power to create and ani-
mate images is either the sole preserve of the Demiurge,
or an infernal wellspring of demonic *energia* worthy of
condemnation. In either case, the faithful are presented
with the paradox that the firṣt act of vivified image-mak-

19 King David danced naked before the Ark of the Covenant, as
was the ancient tradition for venerating statues of Baal.

ing originated with the supreme deity, together with the notion that image-making and veneration is an abhorrent act.

Despite ancient religious bans upon idols and their worship, the holy images of the gods persisted amongst the inheritors of Rome, itself a great reservoir of effigy and idol magic. The 'triumph' of Christianity over older 'pagan' religious imagery was dealt a blow in the early Renaissance by the rediscovery of ancient pagan iconography in subterranean grottoes, and its gradual incorporation in the design elements of gardens, architecture, visual and literary art.[20] Whilst the Gods of Old Rome and Greece were not officially revived in religious cults, the surface images of European culture suggested precisely the opposite, intimating an ingression of ancient power, via æsthesis, into the art and magical philosophy of the present. Embodied in these images were attributes of divinity absent in Christianity, particularly nudity, romantic sexuality, license, fertility, and the virtues of 'wildness'. Thus was the outpouring of sexualized 'pagan' imagery permitted in the context of ornamentation and philosophical contemplation, even whilst Protestant iconoclasm raged during the Reformation.[21]

20 Jocelyn Godwin, *The Pagan Dream of the Renaissance.*
21 Iconoclasm, or the destruction of religious iconography for political or religious purposes, has an ancient pedigree in Judaism, Christianity, and Islam. For a window into the mind of the Early Church on these matters, see Tertullian's *De Idolatria.*

This persistence of image also occurred within Christian iconography, and passed, as a stream, into local religious experience through the monuments, texts, vestments, and relics of the Church. Where such images encountered complimentary folk belief, syncretism occurred, as has been the case for thousands of years, and was adopted by the endemic template of magical practice. Thus to the Christian, the Crown of Thorns is the symbol of the kingdom of earthly suffering. To the witch, it symbolizes many things, such as the inviolable and protective nature of the Magic Circle, and the forces of severity wielded by the Lord of Nature. In the mysticism of the Sabbatic Current, it may also typify the stance of the adept as the kingly assumption of Ordeal: not, as some would have, as the agency of victimhood or martyrdom, but as *prima materia* to be transmuted into Alchemical Gold.

The prohibition and destruction of images, especially those of spiritual of magical significance, betrays a particular split personality of the sublimated demiurge: the religious drive to consecrate raw materials for images of power, and the impulse to neutralize that power through destruction of the created image. Rationales for iconoclasm often become skewed, especially where they maintain that idols are 'merely' images and contain no divine power: such reasoning implies the estate of an inert object, incapable of inciting emotion, inspiration, or any other state of consciousness in the beholder. In this case, destruction of the images would be unnecessary

because of their impotence, but also due to the impervious sensoria of those who behold them. The culmination of the cycle of iconoclasm may thus be seen not only as fanaticism, but also an implicit acknowledgement of, and an assault upon, the powers inherent in the human sensorium—the magical potentials of beauty, ugliness, and the Imagination itself.

To its body of practitioners, witchcraft as a tradition of magic is an Art. It is also, as part of its name implies, a craft, suggesting the action of disciplined object-fashioning. As part of its image magic handiwork, the practitioner of witchcraft may subvert the errors of Iconoclasm by embracing it as a conscious magical process. When an object is created, part of its process of manifestation is the knowledge and intent that it will be sacrificed, as an offering to the spirit-allies of the sorcerer, his fellow adepts, or his ancestors. Such are the Formulae of Iconoclasm.

The formulæ are exacted by any number of ritual procedures, but the most common is the sacrificial pyre. Such sacrifices are referred to in some witchcraft circles as 'marriages' because the image, or earthly form, is wed by magic to the flame, and the resulting union serves not

only a propitiatory function, but also to liberate speci-
fied qualities of power. The bond of betrothal is absolute,
because sacrifice and flame belong to each other, and
none other; as with the sexual act, the sacrifice relies
on the committed totality of each, burning until each
is spent. Knowledge of destruction-in-creation thus op-
erates at a sexualized level, preparing both bride and
bridegroom for their nuptials, and serving as a driving
ethos of aesthesis. Not only must the image be worthy of
the fire, but the fire must be worthy of the image, kindled
to great heat with holy and fragrant woods. Their union,
as part of the realization of each enchantment must be
perfect, the compound image of their conjunction for-
ever impressed in memory, and in the æthyr, rather than
on paper, canvas, or wood. In this manner the base rage
which typically afflicts Iconoclasm is transubstantiated
to ecstasy, holiness, and divine glory.

Paradoxa

I

An idol is raised in the temple of the High Holy God, and receives praise and libation. On seeing the statues, the Affronted Ones crieth aloud: "mine eyes offend me" and so, in accord with the scriptures, they pluck them out. All offense is thus put to rest, save that of the eternal castration of Discernment.

II

By decree of the Patriarch, the Temple of Jupiter is ransacked and its images destroyed. The Cult is declared anathema and criminal, and upon its rubble is raised the Basilica of Saint Whomever. But in this act of Iconoclasm, a thousand more sinister idols are created: the historics preserve these *simulacra* in their record of the rape of the Old Gods by the insane acolytes of *Christus Troglodytus*.

III

Reducing it to its scattered portions, a painting is comprised of flakes of paint, linen fiber, gums and pigments. But it is also formed of passion, of genius, and a haunting of the spirit serving to adhere its many powers. Such are the hordes the Daimon of Art, perpetually called to muster, in eternal assemblage and fragmentation.

IV

The Works of the Master are copied to gain knowledge of technique, and the discipline of commitment to manifestation. Those who vaunt such imitations as original, or as genius newly-emergent, not only besmirch tradition, but would also deign reduce the gods to speaking with the voice of the Ape.

V

The inward face of the Witch's Circle radiates the familiarity of the alien; the outward face of the witch's circle betokens the dark alienation of the familiar. Only by mastering both may the witch conjure all forms.

VI

Formula of Iconoclasm: let the Artist go forth beneath
the Veil of the Mistress Despoina, there to sunder the
Image in sacrifice, portion by portion, according to
pleasure. If the pleasure is mutual, reward shall follow.
If pleasure is found wanting, the Body of the Artist shall
become the immolated, sundered limb from limb.

VII

Separation of the Image from the substance of its maker
constitutes the Primal Iconoclasm: the moment of Frag-
mentation of Self. Where this obtains in the constructs
of magic, three worlds are enriched; where it occurs with-
out empowered intent, a pernicious vacuity shall result,
emptying the Vessels of the Muse.

VIII

In the Arena of Witchcraft, Self is not singular, but a
Temporal Unity of Many. Perpetually emergent from la-
tency, the *ingenia* of the Body may generate an infini-
tude of visages, each with the ability to project an imagic
form, or to serve as the animating shadow behind the
Mask.

IX

Formula of Iconoclasm II: Magical Images, as the fire-begotten Children of Re-presentation, ever rely upon the Wisdom of Assembly. Let then All perceived by the senses be magically fragmented within the Sensorial Void, each portion to serve as a Master to the Apprentice. When each has showered favor upon its disciple, let these teachings, strange and rare, serve as the empowered atoms of the Demiurge, ever to manifest the cosmos according to Will.

X

A Cult of Destruction emulates the fates which Matter itself is subject to: even Terra Mater thrusts her mountains into the fiery chasms, only to raise them up again as new Earth. But in their zeal, let not hubris constrain the piety of the Cult: they too shall be annihilated, in a sublime act of sacrifice unto their god.

XI

Perfected Forms represent a Singularity of Artifice, with a highly constrained set of possibilities, and a narrow modality of manifestation and perception. Where Inspiration is similarly constrained, seek amid the rubble and

ashes of the Fallen for those embers which still glow: let the Magical Artist, no matter his level of attainment, each day destroy and make himself anew.

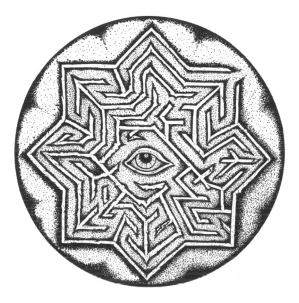

3

THE OPTICAL ARCANA
OF WITCHCRAFT

AS A MATTER of its unconscious function, the organ of
the human eye is evolved and trained for assessment of
its surroundings. A portal admitting light and darkness,
it is connected to a larger sensory complex which con-
stantly strives to impress meaning upon all that it sees.
Willed usurpation of this instinct occurs during ritual
devotion to, or adoration of, images such as statues,
magical seals, icons and paintings, as a unique modality
of sight is in force.

Separated from the usual drives to assess, the magical
Eye is connected to the emotive body of the Heart, as
well as the sensorial contours of the flesh, and visual ex-
perience may thus be realigned to tactility and motion,
connecting what one sees to what one feels, rather than
thinks. Being a different form of experience, the image
is experienced not in terms of its defining criteria, but
rather its relational stance to the magical Self, or its dei-
fied status as an essential occult power.

And yet, where the rites of image-veneration are con-
cerned, devotion in itself is an act sufficient to require

no modifiers, as is Love. The relationship of a devotee to his gods or spirits therefore embraces special criteria of relation such as humility, receptivity, and the level of trust between power and its recipient that allows for trance, vision, and ecstatic rapture. Accordingly, this acknowledges the crucial position of Self in the magical formula, and devotion is not therefore merely a 'selfless' religious act, meant to empower a priesthood: it is part of a reciprocal relation to spirit, part of which is empowerment, through ecstasy, of the adorant. Such is axiomatic between Lover and the Beloved.

This principle is also active in images that have no known relation to spirits, gods, or entities other than the imagic representation itself. If an image delights the Eye through visual æsthesis, mundane perception is usurped and the emotive body is engaged. This action occurs as a natural part of religious fervor, magical ecstasy, and indeed sexual devotion.

A petroglyph marked on a lone boulder or standing stone will embody distinct powers for those who initially inscribed it as an act of cultic or artistic activity. As a ruin, encountered centuries later by a different body of people, it will not convey the same set of meanings, nor even the same fundamental dynamic of viewing. But its essential and embodied power remains and, it may be argued, operates in a limited magical fashion, beneath the mantle of present awareness, due to the beholders' lack of origination-reference or 'insider knowledge'.

For the practitioner of image-magic, the danger of

such encounters is not that the 'vulnerable' subconscious mind of the later viewer is penetrated by an unknown and potentially hostile force, but rather that the perceptual impediments of the modern eye *prevent* such a possession. Lack of origination-reference does not imply the absence of reference: the aforementioned witnesses will carry with them knowledge and assumptions arising from semiotics, history, archaeology, nature, time, and art, to name an important few. Magical perception of the object, therefore, is impeded by successive cascades of mental and ocular processes attempting to 'define' the object and thereby subverting the magical sensorium.

These processes, most of which operate at strata below consciousness, are artifacts of deeper demons, namely unexamined empiricism and fear of the unknown. In essence, the sensorial permeability which fosters gnostic and ecstatic experience is blocked due to conscious, irrelevant projections onto the glyphs. Therefore, where unknown runes are encountered, they are best greeted by the magical inception of a state seeking to prime the sensorium as an empty vessel.

The estate of the empty vessel, far from being an idol, is, rather, the altar upon which it shall rest, and the temple

in which the altar ſtands. It may be attained in a number of ways, one of which is a practice whose aim is the re-ordering the visual sensorium.

THE SALUTATION OF THE UNHEWN STONE

Arranged in silence and presence before any object, one becomes acutely aware of one's present location in space and time. Each temporal detail of the surrounding environment is experienced consciously and separately as individuals, rather than as a contiguous and ambient whole, and the exercise is conducted rapidly, like beholding individual leaves upon a tree. This simultaneity of individualized perceptions is gradually increased until the sheer quantity of sensorial impressions eclipse the conscious operation of the exercise. At the moment of greatest experience, one allows all things perceived to pass beyond their sensorial criteria. The same perceptual exercise is then undertaken with the Self as the focus. Lastly, the same is done with the Object of Fascination.

This ritual principle is advanced from passive to active forms in the Art of sigilization, whereby archaic principles underlying the formation of the phonetic alphabets are engaged anew. In higher operations of this sorcery, sigils are not only invested with quintessence but also with belief and non-belief.

The Eye & The Circle

The Prime Sigil of the Witch is the Circle, the vivified image of which is created in the same context as its veneration—the High Sabbat. The Magic Circle is thus the Arena of Eternity, its respective orientations, according to differences in traditional lore, may include the Compass, the Mill, the Plot, the Charnel Ground, and the Wheel of Breaking and Making.

To the witch, the Circle is many things; one of which is the Singular Eye of those Spirits collectively assembled at the Sabbat. Comprised in equal measure of Void and the Flesh of the Adepts, it is empowered as a magical organ of mediation between the sorcerer and the legions conjured. The function is thus a stage of mutual perception between the Gods and Flesh; where this state of perception is invoked as a specific power, the act of Iconogenesis emerges within the three ocular shrines of Witch, Spirit, and Circle. So are the patterns of time, life, and the heavens enshrined.

It is the Circle's relation to the shape and structure of the Eye that gives it especial power over image creation. The pupil, as the circular portal admitting light, the iris as its master, the retina as the web to gather images from a swarm of photic information. Despite the human tendency to portray images in rectangular aspect ratios, this is not the manner in which the eye itself perceives image, preferring instead an ellipse, bounded by phantasms and uncertainty. Peripheral vision, as a function of its differ-

ences from the central field of vision, contains the zones where ghosts manifest, but at the same time, it may be empowered as a zone of witchcraft, both for perception and transmission of power.

PART OF CIRCLE	TYPE OF VISION
Circle: Interior	Central Vision
Circle: Edge	Peripheral Vision
Circle: Beyond	Vision Unrevealed

In the physical world, the perception of an object at a distance presents a tableau of congress which admits influences of every other object standing between itself and the eye beholding it. The nearer the object is to the eye, the lesser the impact of tangential objects upon perception, but the respective perceptual states of near and far each provide important apertures of power, that being object (near) and context (far). Additional phenomena such as light and darkness, atmospheric phenomena such as cloud or mist, all participate in the greater tableau. For the adept, engaged in the magical dynamic of seership, the object in question need not be separated from its context, for it provides additional powers augmenting the arcanum of the object, both seen and unseen. Total focus on the object alone is useful for meditative states, but by nature excludes power. At the zenith of ocular understanding, we must as ever return to the Circle, for what is true of the Witch's Eye is also true of the Body Whole.

The parameters of perception applicable to the visual organ may also be consciously extended to all corporeal apertures of sensory congress.

Image as Magical Artifact

A magical image may produce hypnotic or intoxicating effects under certain conditions of viewing, similar to, and sometimes exceeding, those incepted by the ingestion of narcotic poisons. This occult radiance is the result of careful and skilled encryption of power during the process of image-creation. Successive layers of meaning serve prismatic functions of collection, concentration, separation, and recombination of magical radiances, such that a portal of ingress—a means of entry into the Arcanum—is granted the perceptor, but at multiple levels of reification. Obviously, the potency of such emanation is proportionate to the skill of the Artist and the receptivity of the Medium, but the unskilled viewer may readily become influenced by an ensorcelled image, albeit unconsciously. Other types of altered consciousness may result from these imagic forms, such as physical ecstasy, possession,[22] intrusive horror, transcendent mysti-

22 To possession we may add the peculiar state of *aethyric extrusion*, or the ejecta of Self thrown beyond one's personal aethyric field. In a willed state, this takes the form of the wayfaring spirit-double and is referred to as *'Going Forth by Night'* in the Sabbatic Cultus. When extrusion is accidental, it precipitates considerable chaos in the mind and body.

cal revelation, and spontaneous visions. Indeed, it is this
ability of magical images to generate states resembling
narco-æsthesia[23] that often differentiate magical images
from the nonmagical, at least on the basis of activity.

This analogy with drugs or poisons also opens the way
of warning concerning two perversions associated with
magical images: addiction and overdose. In unconscious
cases, their action becomes demonic, rupturing their ini-
tial magical bonds and forcibly scizing the sensorium
of the viewer. When conscious, this same process can
sometimes be used as a magical technique for incept-
ing altered states of consciousness. Certain remarkable
images, being pure extrusions of spirit, possess these
strongly fascinating aspects independent of any willful
approach, and in their commerce there is a fine line be-
tween rapture and ruin.

Images which are strongly encrypted as magical arti-
facts are usually 'designed' to be perceived in a magical
context, such as ritual or sorcerous action, whether it be
the thaumaturgic strain of sorcery or simply devotion to
a particular spirit. When such images are moved beyond
this field, their emanative qualities become distorted,
though their internal power remains strong. In this man-
ner, they become objects of fascination transmigrated
beyond the *logos* into a realm of pure essence.

23 *Narco-œsthesia*: sensorial ecstasy arising from the use of
drugs or poisons.

Like a seismograph, a magically-created image receives multiple emanations from unseen forces and weaves them into a cohesive graphical manifestation. This reception is both passive, (as in the propensity to harness ambient mood and emotion), and active (where kinesthesis becomes the operating mediator of artistic vision, preserving and encoding magical gestures). Various strata of information thus exist in any magical image and may be accessed through sorcery or ritual. Co-identification between sorcerer and object may complete the loop, as in magico-sexual practices employing witches' fetish-objects such as the Stone God.

Amalgamation of such ritually significant objects may, through certain operations, concentrate their force and efficacy for incepting states of liminal awareness, in a similar manner to the Buddhist *stupa*. In the Western Esoteric Tradition, a similar force of amalgamated *numen* is present in the altar of the ceremonial magician, being a descendant of the Christian altar.[24] As a repository of power-objects, the witch's shrine magnifies this principle, much in the manner of the ritual *mesas* of the *curanderismos* of Peru.[25]

24 When considering the Christian altar as a locus of power, it is appropriate to acknowledge its own descent from ancient Near Eastern, Mediterranean and European religions as the rock of bloody sacrifice, to a focal-point where the act of sacrifice has become purely symbolic.
25 Donald Joralemon and Douglas Sharon. *Sorcery and Shamanism.*

When realized according to cultic principles, the idol occupies a moment of constrained temporal power, extended into the future. This embodiment finds its natural expression in the concept of the coin, an artifact which in ancient times originally bore the images of the deities. Graven with the likenesses and emblems of supernatural powers, the gods were wed with their terrestrial counterparts in the form of precious metals, themselves the result of sacrifice, whether paid in the blood of war or the sweat of the mines. In this manner a threefold formula of spirit-matter-sacrifice gave rise to the embodiment of the Idol as coin. Freely circulated, each man and woman partook of the mystery of the god through the possession—and spending—of its coin. In time, the likenesses of the gods were replaced by mortal rulers, signifying a debasing of the Idol. Similarly, a corresponding debasement of the precious metal occurred, and alloys gradually weakened the purity of the metal, until at last, today's numismatic descendants, in the form of modern currency, neither depict gods nor contain precious metals.

Allied with certain elemental attributions of the Disk or Pentacle—namely Earth and material wealth—the function of the Coin in the Sabbatic Current seems to have adopted some of the conscious cynicism of this eidolic decline, frequently allying it with Judas, an heretical patron of witchcraft, but also of corruption, betrayal and treachery. Likewise, it is associated with Abel, vain lord of the profane and worldly flesh that Cain, the body

of the Sabbatic Adept, muſt slay in order to 'self-over-come'. The word *coin* may also be used in these contexts to evince a betrayal, particularly in its incarnation as the ordinary currency of the mundane world.

A Chriſtian corollary of the eidolic coin retaining ſtrong fetishiſtic qualities was the medieval *Agnus Dei*, a wax sacramental disk impressed with an image of the Lamb of God and a papal sigil, consecrated with chrism, balsam and holy water, and used for private devotion. Possibly derived from earlier pagan praxes involving carrying of wax talismanic seals on the person, some of these disks were fortified with so-called 'martyrs' paſte', duſt ground from the bones of martyrs. The disks were used to protect their owners from disease, provide protection during childbirth, and ensure success in battle.[26] A curious witchcraft association with the Agnus Dei is the Draconic Coin of SA, which each initiate muſt forge individually as an offering to the ataviſtic / anceſtral retinue of spirits. Ideally forged from the impressed earth of an animal's footprint, as well as the 'subſtance of Man', the coin is emblematic of Cain and the horse he rides, thus the Witchcraft Adept and his or her relation to power.[27]

26 Sally J. Cornelison, and Scott B. Montgomery, eds. *Images, Relics, and Devotional Practices in Medieval and Renaissance Italy*, pp. 144–148.

27 Andrew D. Chumbley, *The Dragon Book of Essex*, 'Sa: The Rite of the Turnskin'. Though this book is properly considered ceremonial theurgy, it contains elements of witchcraft,

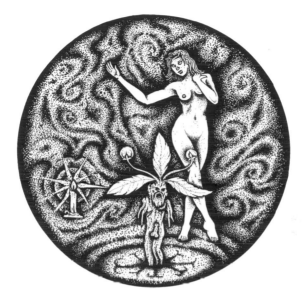

Relationality and the Witches' Glamour

Witchcraft is haunted by the concept of the *glamour*, which posits an outer illusionary form projected by the witch as a form of sorcery. A well-known example of this is the transmogrification of a grotesque, elderly crone into a comely and nubile maiden, or vice versa. Both of these female physiomorphs are deeply rooted in the

and is a brilliant and highly original reification of Chumbley's work.

iconography of witchcraft. The conventional esoteric understanding of this mutability has rested upon several assumptions, the first of which is that one of the two faces is real, and the other illusion. However, when both forms are abstracted beyond the realm of the absolute-corporeal, they are liberated from their fleshly moorings and participate in a shared continuum, thus possessing equal measures of the 'real' and 'unreal'. That both, as perceived forms, emanate from the origination-point of the witch, indicates a mutual indwelling of forces and forms within a shared arena of power. Thus, the common point of origination and the interchangeability of projected types blurs precise demarcations between the 'real' and 'imaginary'.

This should not be surprising, given the degree of liminal types and magical stances indwelling witchcraft. An axiom of magical imaging inherent in this example is that the *numen* or vital indwelling force of a thing, may grant it a more coalesced and compelling form in 'reality' than an actual physical body. Thus, in this state of reckoning, the 'real' is no longer anchored to the physical.

The second unacknowledged premise is that these two witch-types are opposites. Most often these polarities are first perceived as existing on a continuum of physical age: one is a youth, the other an elder. This assumption is illusory however, for in such a scenario the maiden would be replaced by a female infant, thus patterning the Dawn and Twilight of the Wytchan priestess. The nubile witch and the crone are, rather, polarities on

the continuum of female sexual *fascinum*: one of attraction, the other repulsion; one of waxing sexual foison, the other of waning barrenness. Both of these projected witch-powers, as imagic projections, fulfil specific esoteric functions in both witchcraft iconology and the Grand Rite of the Sabbat. Additionally, each rely on imagic power which specifically disrupts modes of perception in the viewer, rendering them vulnerable, either to allure or to revulsion.[28]

There is an additional stratum of meaning in the historical example of the sexual glamour: the implication that the image-making power of the witch is directly associated with the body, especially the arenas of magical sexuality, resonated through multiple layers of ritual enchantment. This alignment of creativity with the sexual selves is a natural correlation, due in part to its procreative aspects: the reproductive potentials have been expanded beyond a biological mandate into the spheres of image generation and sensual perception, fecundating the act of re-presentation, whether it be a magical image or the appearance of the witch herself.

These principles are greatly magnified through the simultaneous development of artistic skill, sexual magical practice, and understanding of the perceptual fields of those who encounter the image. This latter criterion sug-

28 Intentional congress between such powers is suggested as a magical formula for the 'destruction of personal aesthetic culture' by Austin Osman Spare in *The Witches Sabbath*.

gests that the production of all truly magical images is ultimately congressive, whether the Image interacts with a person, a spirit, or the empowered Eye of the Artist. Within the Sorcerous Atelier, the perfected body resulting from image-magic is not a fœtus, but more akin to the *homunculus* generated of the magical self-coition of Artist.

Though part of its wellspring lies in the vast sexual strata of the witch, the glamour as a practice of corporeal image-magic may be extended beyond the realm of sexuality and the body itself, to ensorcel other imagic forms. One of the simplest of these is the sigil or magical glyph, which may attain form by a variety of routes, including sexual iconogenesis. Yet the indwelling *numen* of the final reified form is abstracted beyond conscious perception, such that it embodies an occulted principle, a shadow or glamour, of its interior fire. Conscious engagement, such as the perpetuation of the sigil through writing or carving, is but one of many magical routes of access.

Images of witchcraft exist in the realm of sorcery, to operate primarily as conduits of power according to the design of the adept. Born first of the emptiness beyond Self, their perfected forms arise in response to a fluctuation of congressive power which rises many strata before the logoic. Inhabiting first the æthyr, then the dream, then the dark fields of atavism latent within the incarnate flesh, then magico-sexual corporeality, then creative awareness, then the intellective mind, they cycle through

these states, gaining incarnative form, and ultimately manifest through the Eye and Hand of the Artist.

In consideration of this, the Idolater-Artist cannot ignore the phenomenon of multiplicity of interpretation—an image may mean one thing to an initiate, versed in the rituals of its parsing and decryption, and yet may mean something entirely different to the uninitiated. Thus, when fashioning the image, the Artificer of the Divine Image takes multiple viewpoints into consideration and allows for their mutual tessellation. Symbol is thus rendered in such a manner that it presents itself anew with each reading, according to context, and the unique mind of the reader. In this manner, the same words may be read by a thousand different eyes, and have a thousand different meanings, all of which are true.

Concealed & Revealed Images

Historically, a substantial number of witchcraft artifacts have been discovered buried, secreted in the walls of houses, under floors and crossroads, and at the bottoms of wells or springs. Despite their appearance as imposing material forms, their creation doubtlessly included the intent that they were to function at peak level in an environment of darkness and secrecy, hidden from sight. Because of witchcraft's hidden nature, the vast majority of its work—from the active sorcery of rituals and spells to the material embodiments of its Fetishes and magical instruments—remains concealed. Its outer

representations thus serve as mediators, self-conscious of their stations as liminal, and partake of a duality of reference: the *signified* and the *potentially-signified*. Both states convey unique power as individuals; working in tandem, they generate a field of magical influence allowing the expansion and rarefaction of Belief. As a Magical Formula of the Sabbat, this principle allows for the construction of the 'Open Vessel', a station which, though its boundaries exemplify extremes of structural integrity, is nonetheless vulnerable to penetration of its interior.

Effigy-Consciousness

In folk Christianity, where sorcery and religion are strange and often unacknowledged bedfellows, the discovery of miraculous images buried underground, in streams and wells, represent a distinct form of spirit-intercession. Such images were more than the phenomenon of *pareidola*, and included the discovery or appearance of what the sorcerer would call fetishes: statues, crucifixes, and other objects. In particular, the Marian cult was especially rich in miraculously or 'self-revealed' statues; and it was the event of revelation itself, in addition to the sacred objects themselves, which formed a crucial component of the magical experience and reificatory power.

The initial finding of the holy objects may have been part of a greater magical circuit preceding the event, including prayer, pilgrimage or dream-revelation. As

William A. Christian notes, these discoveries later led to the establishment of holy places and shrines *in situ*, and formed an essential bridge between Christianity and the powers of Nature among rural practitioners.[29] These magical manifestations echoed the epiphanic discovery of sacred idols in earlier ages, such as that described by Pausanias in the cave-shrine of the goddess Despoina:

> the throne on which they sit, along with the footstool under their feet, are all made out of one piece of stone. No part of the drapery, and no part of the carvings about the throne, is fastened to another stone by iron or cement, but the whole is from one block. This stone was not brought in by them, but they say that in obedience to a dream they dug up the earth within the enclosure and so found it.[30]

A similar relationship to 'revealed' holy and numen-bearing objects endures in the ancient Tibetan Buddhist and Bön traditions of the termas.[31] The state of 'revelation' consists of a state of contact with a zone of power conceived of as being 'beyond self': the spirit-world, the Otherworld, or simply 'otherness'.

29 William A. Christian, *Apparitions in Late Medieval and Renaissance Spain*. This revelatory tradition also includes the 'revelatory' discovery of the corporeal remains of the Saints.

30 *Description of Greece* 8. 37. 1–8. 38. 2

31 Tibetan གཏེར་མ་ *gterma*, 'hidden treasure'.

The Witches' Sabbat
As an Origin of Magical Images

The magical unearthing or excavation of magical images in times past possesses a counterpart in witchcraft, in the spontaneous emanation of bizarre visions and sensations associated with the Witches' Sabbat. Writers on contemporary witchcraft practices have previously noted that the Sabbat, being the primeval rite of the witches, often produces distortions of time and space, as well as kindred sensorial grotesqueries. The Sabbat contains a disparity of magical elements such as absolute mental focus, sensory overload and deprivation, extreme physical exertion, as well as, in some cases, the use of magico-sexual technique and the ingestion of psychoactive preparations. Although any one of these elements is often sufficient for incepting a flood of magical images, it should be remembered that a great number of witchcraft rites make use of none of these techniques and instead rely wholly on the conjuration of spirits and deific forms, the presence of which creates a distortion of form.[32]

As a natural consequence of the ecstatic states thus induced within the Witches' Circle, imagic aberration extends to the entire sphere of experience within the Grand Rite itself, including both its recollected memory and its immediate impress. In describing the subjectiv-

32 Hamilton-Giles, P. *The Afflicted Mirror*. Three Hands Press, 2013.

ity of the initiate's experience of the Sabbat, Andrew D. Chumbley noted this irruptive phenomenon with particular descriptive force in his essay *Wisdom for the New Flesh*:

> *To some this Vision is full of glorious imagery, where angelic nymphs will lead them carousing and singing to feasts of delightful superabundance. Yet to others it is an infernal pilgrimage, traversing gulfs of pain upon ladders of knives, jostling with concupiscent hordes of half-formed Satyri and Succubi unto the oft'-bloodied altar, where the Anus of the Goat is kissed as though it were the tender lips of a Proserpinian Virgin.* [33]

Overcome by a flood of sensorial activity on both interior and peripheral levels, the varied perceptual gateways of the body of the adept struggle to establish coherence. When subject to the vagaries of this hyper-sensual storm, the distinction between the pathway of the witch adept and the shattered vessel often lies in the willful suspension of the perceptual order. Surrender to this deluge of alien revelation, rather than attempts to impose mundane structure or sense upon it, allows the genesis of a transcendent magical state. Although such consists of giving oneself wholly in trust over to the possessive state of 'beyond' or 'otherness', such is the very rubric of *ecstasis*.

33 'Wisdom for the New Flesh', *Starfire* 1994.

Aside from the diverse magical techniques of witch-craft and the effects upon perception caused by the distorting presence of manifest spirits, another important component of the Witches' Sabbat is the forceful overshadowing of the conscious Self by the Atavistic Body, that being the sentient latencies of pre-incarnate Being which are roused either deliberately, or by accident, by the magical transgress of the senses. As I have noted in a separate paper elsewhere,[34] the vivified ancestral substratum of the body is a defining feature of Sabbatic Witchcraft, and likely one of its oldest magical strands.

The depths of the human psyche contain an infinitude of images charged with power, whether having their origins in emotion, historical experience, dream, psychosis, phantasie, or the figurative realm of occult practice itself. These strata, interpenetrating the atavistic, are amplified in the rarefied magical arena of the witches Sabbat, which possesses its own visual ciphers serving as rudimentary zones of power. Ever-present, they penetrate all acts of power whether intentional (as sorcery) or ambient. In the distorted temporal fields of Sabbatic reception and projection, the Artist-adept may partake of these natural imagic strata, not only as Muses but also for the understanding which arises as a result of the recombinant graphical forms. In their receptive forms, they are the material of theophany, in their projective

34 'Anatomies of Shadow' *The Cauldron* No. 149.

forms, they are the very pigments and brushes of the occult artist.

Magically, these upwellings from the atavistic reservoir are experienced in particularly visual forms, not just through the distortion of image, but through actual mutation of form, whether it be the assumption of morphological or wisdom-attributes of bestial-dæmonic forms, or the observation of those characteristics in others. The frequent depiction of such forms in the elder iconography of European witchcraft serves as a reminder that the conflation of human and animal states was at least compatible with popular conceptions of witches, who assumed the ritual therianthropic forms within the bounds of the Sabbat (part human, part beast) or as part of the ritual of night-flight thereto, where winged and nocturnal creatures such as the bat and owl held prominence.

During the ecstatic frenzies of the witches' night-conclaves, each of these assumed atavistic states offers a visually perceived form (as seen or experienced sensorially from without), as well as a unique perspective experienced within. For example, the sudden spiritual overshadowing of a priestess by an owl-form, or its selected bestial organs, may provoke horror or fear in those who witness it, not only because its appearance is unexpected but because its figuration is incongruous with both Owl and Woman. Yet, the one directly experiencing the descent of the Daimon into her flesh may enter into a sublime reverie which offers a uniquely empowered

window of perception. Each perspective, Seer and Seen, offers the Magical Artist a wealth of tutelary power concerning the figuration of spirit and occult energies. Both perspectives may be drawn upon in the memory of the Artist, for the willed overshadowing of aesthesis, long after the Sabbatic revels have ceased. Further, the use of graphic re-presentations created during such reveries, in the form of images, letters, shapes, and seals, or gestures used in their creation, may serve as concentrated gateways for returning to such states, and offer this power in accordance with the skill of the Artist and the force of the initial possession.

4

ICONOGENESIS

IN THE MAGICAL re-presentation of sorcerous fashioning, form, otherwise determined largely by utility, is defined both by magical function, and the Arcanum of its presiding spirit. Material corpora thus devoted as conduits of divine power are magically reckoned as the gods or spirits themselves, above and in addition to their more common conception as 'portals' by which to access that god's power. Thus, an entire array of such cultic objects ceases to be 'tools' or 'instruments', and becomes instead Legion: an Assembled Host.

Where vital spirit-presence attends, this ethos of magical fashioning is operative across the entire spectrum of witching objects. In any consideration of fetishes, any number of these objects might be referenced, but the Witch Bottle, given its well-established historical record in relation to witchcraft, is particularly appropriate. Such artifacts naturally include the iconic salt-glazed bellarmine jug of the 16th and 17th centuries, but also representations in glass. Exterior forms of these artifacts varied from grotesque bellarmine countenances to visually neutral forms, but their interior forms were remark-

ably similar: pins, nails, thorns, sharp bits of bent iron, knotted cords, hair, sigilised parchment, and urine, forming the 'organs' of the embodied spirit.

Given that the magical functions of the bottles—as is currently understood—was remarkably similar, their morphology implies of an entire ethos of sorcerous molding, one which allows great freedom for the artist, but also which has definite patterns and protocols of conception. Still other witchcraft usage of vessels included 'spirit traps', as in the bottle-trees and witch-balls of North America, and their use as concentrators of spiritual force in both Essex and Derbyshire traditional craft, also follow these historical patternings to a greater or lesser degree. In all cases both the magical process of fashioning of the vessels, as well as their appearance, are accompanied by an embodied presence which can be distinctly perceived, even by those who are not particularly disposed to magical ideation. Though possessing strikingly different powers, Cauldron, the Cup, bowl, and the Poison Bottle are all part of the kinship of the witch-vessel, though each partakes of a separate magical pedigree. Other specialized vessels also obtain, such as those fashioned and dedicated for specialized sacramental wines, the vessel and liquid being 'of one being', i.e., united as Entity.

In consideration of magical image-making, certain traditional methods are employed, long asserted to benefit the work. Before power assumes shape or form, its *formless* attributes are invoked; thus is conceived the

precise shape of the space it shall occupy. This conjured shape is not only dimensional, it embraces powers, desires, constants, and deviations. The potential presence of each form is known and prefigured by the character of its absence. To the operation, this is the state of being equivalent to the Circle itself, the Virgin Ovum prepared for connubium.

The same considerations hold force when the raw substance for the Image is gathered up from the heart of the world. When spirits are cast in metal, we obtain virgin iron, bronze, copper, silver, or gold, and hallow the ingots with the seals of their spiritual governors, even before they are melted and cast. Likewise, we hallow the furnace and all tools thereof to the ancient and sovereign gods of making: Azazel, Tubalcain, Hæphestos, and Vulcan.[35]

Pre-incarnate sorcerous conception, impressed upon and within raw material consecrated for Effigy, participates in an understanding peculiar to traditional witchcraft, which has been called *The Fates of Matter*. This is the idea that the embodied spirit or god dwells in a dreamt state prefiguring the formation of the Idol. This dream is the foreshadowing, within wood, clay, stone or metal, of the cartography of the possible. Such Fates are not cer-

35 Alchemic patination of metal, serving the magical parameters as an animating fluid, may be accomplished by using suitably acidic or alkaline formulae, such as urine, blood, salts of copper, liver of sulfur, and verdigris. For those versed in the Mineral Work, the possibilities are endless, and frequently hazardous.

tainties but rather predilections and proclivities—lines of recognized fortune that may mark the material for a particular 'divine' purpose. When these converge with the inspiration and calling of the sorcerer, a revelation of Fate is made that marks the substance as chosen for the Idol.

The use of the Libation—sacrificial blood, sexual fluids, narcotic wines, water drawn from natural springs—form the umbilicus of the work. Aside from the phantasmal tether binding the image to its creator, it is also used as *mumiya*, the ingressive and generative substance of the Idol. The libation is an emanative means of spirituous procreation, its sacrament being the magically elevated products of the incarnative Self. Through conscious magical separation from the carnal host, the Seed goes forth beyond Self and becomes Other. If it unites with an allied seed of the spirit-realm, the Effigy is awakened. The division which occurs in this moment of sacrifice must be absolute in its magical will, desire and belief—as well as its consecration solely to the purpose of empowering the image.

With each image made, the Magical Artist becomes encrypted in the material substrate of form, though in a distorted sense, as the ingenium has processed outside the temporal bounds of Self, and thus beyond familiarity. This process occurs regardless of conscious awareness and may result in a reciprocal grotesquerie: the Self-perceived-as-other. The most skilled images thus made produce a distorting effect on the perception of the viewer,

though such often initially lurks below consciousness. When realized, the image gains the ability to access the world as an eidolon of the Artiſt, beyond the conſtraints of the physical body. The reverse is also true: one who partakes in sensorial congress with the image may also access the chosen *eidolæ* of the Artiſt.

This magical formula, which has passed through the ages in various forms, is sublime and may be successfully accomplished by the solitary Mage, but if it can be maintained as an efficacious operation by a supremely focused body of adepts, its power may be vaſtly quantified. Such is one pathway of the High Sabbat, in which the sum emanative sexual force of all adepts aligns to manifeſt the Infernal Protoplaſt, the prefigurative form of the Opposer and the Black Man of the Sabbat.[36] Although such rites are traditionally theurgic and used for the Witches' Theophany, they may also be used to concentrate power and vitality within a magical image, or other cultic objects borne of sorcerous fashioning.

Blood and sexual secretions may also form the basis of magical pigments, inks, and paints. This latter method appears in the work of 19th century American magician and myſtic Pascal Beverly Randolph. His work *Magia Sexualis* detailed the doctrine of the Living Magical Picture, which may be magically charged to exert influence over the beholder. Such images are animated with Fluid Condenser, a preparation containing plant essences,

36 Identified with the Devil in British and American folklore.

blood, and human sexual fluids, and 'insulated' with gilt frames. Citing older magical operations for animated paintings, Randolph says:

> *Of other receipts we see, that if one mixes into the paint some drops of the blood of a pure virgin, who is offered, after this, to the pleasure of a succubus, one may give formidable power to a living picture.*

The mumic emanation, ritually produced, should bear the deific impress of the god or spirit to be animated, and ideally is extracted during ecstatic possession by the entity.

We may also consider the relationship of Sigil, Amulet and Talisman to the Idol, as they are graphical, abstracted forms of spirituous powers, accessed initially through the sensorial arena of the Eye. The animation of figures by sigillic inscription, or by automatic engraving, is a procedure well known in many witch-circles, and an ancient component of magical image-making. One particularly germane antecedent is the *golem* of Jewish mysticism. As part of its magical awakening, the figure's forehead was inscribed with the word *emet* (truth); this bears similarities to the ancient Egyptian servitor figurines known as *ushabti* ("answerer"), as Moshe Idel has noted.[37] Where focused trance can be maintained for the

37 *Golem: Jewish Magical and Mystical Traditions of the Artificial Anthropoid*, pp. 3–4. Idel also notes the similarity of the ancient Greek story of Prometheus and Dolus.

duration of sigillic impress upon the image, it potentiates the process of actuation, and delivers the æthyric shadow of the written cipher, as formulated by the Grand Triangulum of Art.

These principles also apply to wood, harvested from the wild with suitable offering, or hallowed stone, quarried direct from the flesh of the Earth by one's own hand. In all cases, in accord with the doctrines of the Fates of Matter, the artificer must recognize the raw materials of the idol as an organ of the deity long before they assume any iconographic shape, and relate to them thus magically.

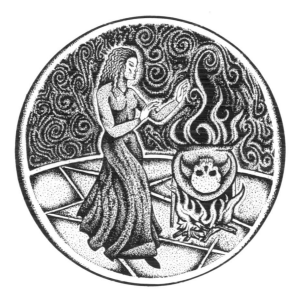

Formulæ of Iconogenesis

I

The Word is invoked in the name of God; its slaughter and suppression seeds the Field of Image. The Field is fertilized with the Elixir of Copulation, prepared in strict devotion to the image's animating spirit. When living blood is poured out into the furrows, heads erupt from the soil. The Field is abloom with faces.

II

A severed head is animated by black magic, and in the course of its awakening serves as a prophetic oracle. But it is the act of severance, rather than the spells and seals that accompany it, that grants the head its power. Such is the font of all Living Images, being the artist's willed self-decapitation and transmigration of spirit from the body into the canvas.

III

Tension in re-presentation between the preconceived and the spontaneous prepares an habitation for spirit.

Either may become a Tyranny: when usurped by the Artist, ingenium procreates.

IV

Particularly potent scenes of images witnessed from life of horror, ecstasy, suffering, rapture, creation, and destruction, may become impressed in the memory, retaining the power to haunt over time. This marking of the Mind's Eye mimics the physiological action of the carnal retina. Such fixed images, when unconsciously formed, may become despotic, and indeed possess the beholder to an eventual pathology. The Magical Art, however, may utilize such potent experiences for empowering personal gods. In like manner to Idols, they may move from the sphere of the imaginal-obsessive to the manifest-devotional. Care must be taken, however, during this transition, that the process of embodiment leaves much to chance, for the artist must be as much medium as engineer.

V

Living Images act as portals, through which the Eye passes into Beyond. Dead images turn the Eye elsewhere...or else attract a swarm of detritovores.

VI

Devotion and Ardour shall intervene where the Hand and Eye admit passion in equal measure to skillful exaction. The rough-hewn heathen idol may hold discourse with the finely-chiseled god of marble, and indeed may subdue it, performing ever greater miracles.

VII

Through the manifold carnal bodies generated of inspiration, flesh may copulate with flesh within the singularity of the Artist. Where Hand and Eye are met in this hidden bedchamber, manifestation of Image may be reciprocal, harmonious, and oppositional in simultaneity.

VIII

Unexamined Ego is a grotesquerie of Mind, whose influences pollute the Blessed Amnion of the gestating Image. From it proceeds the Ape, enemy of the Artist. Let Mind therefore endure careful scrutiny, that its minions be clearly tasked, and the Heart gain ascendance as the progenitor of imagic forms.

IX

The power to conceive and awaken the Living Image is great, but greater is the power to be ravished by it, and emerge as Flesh Anew.

X

The Living Image is as a Book unto itself, being but the surface manifestation of its hidden radices. Successive fields of emanation radiate outward from the image, each a text and subtext. The subtlest among them emerges from its hidden interior—the Citadel of the Divine Artist.

XI

Extrusion of Self beyond the bounds of the self-conceived may be crystallized in the form of Other, as an emanant attaining absolute sentience. And yet for this to occur, the umbilicus, once it has served out its Fate as a conduit of nourishment, must be severed in bloody sacrifice, lest both Self and Other be strangulated in the Fields of the Equivocal.

XII

The Heresy of Animism embraces the Light of All-Enchantment: if All lives and self-conceives, then the All-relational, through Art and Congress, is possible.

XIII

The Monument is not erected to create a mark by which one will be remembered, but rather which will magically incept a state of Remembrance in the flesh of the present, to supremely empower futurity.

XIV

A statue is rais'd in the Forum, and showered with roses and blood by the hordes. In time its fame and genius are firmly fixed in temporal Dominion. But the Effigy which arises in darkness, and is carved and adored in Secret by the *via mystagogia* participates in the Secret Connubium of the Imagic Wedding. Its power and presence are fixed in Eternity.

XV

Formation of the Graven Image is a crystallization of power, according to the mandates of metallurgy and sorcery: as the cast metal cools, its crystal structure solidifies its form. Similarly, its imagic particulars also endure a crystallization of form which, like the Stone itself, references a concentrated reification of power. Thus, the Image becometh in flesh a simulacrum of stone, whose animation and life is aided by the otherworldly source of its origin, and the worldly source of its veneration.

XVI

The Living Idol is the body of the adept, raised from the estate of *hyle* to the station of god. This is achieved by the constant discipline of overcoming the vain delusions of Self, each as an intruder slain singly in the sacrifice of illumined power. In the Congressus of the Art Magical, let all adepts thus be adored.

XVII

The Body of the Beloved is the Living Idol, in whole and in part to be adored with magical formulæ, more so than any Image of Brass.

Through the act of exhortation, libation, and the Divine Caress, all flesh is augmented with the procession of divine intelligences, and expanded beyond its present form within the Circle of Art. According to this art, an infinitude of statues may be made: living, dead, and asleep, filled with strange dreams of their wondrous awakening.

XVIII

Our self-manifest Angel draws her material form from the collective flesh of the body of the initiates; the Great Circle of the Sabbat is her Womb. When arising as a collective inspirational node from the Great Congressus, the sense of *otherness* which arises in the percipient becomes reciprocal, and the once-prefigurative draws breath.

XIX

Formula of the Emanant-I: with the genesis of magical images, a moment arises when the execution of form eclipses both meaning and mundane understanding, and is an extension of Pleasure. At this moment, the rigid architecture of the Temple vanishes, and only its porticos remain, the *pronaos* of the ever-oncoming rush of spirit-horde.

XX

The Hidden Image, if truly magical, dwells in a space beyond mundane mediation and representation. Within this aethyric sanctum, a tension is generated between the Hermitage of the Unrevealed and the field of possibility which lies beyond it, a state of undifferentiated power like unto the Desire of the Virgin, the Formless-seeking-Form.

XXI

Where the Eye lacks magical empowerment, Ego becometh as the Unconscious Mirror of Void-Self, endlessly disgorging entrails.

XXII

The witch seeks not to unmask the Masked, but to perceive Mask and Face as One in congressive totality, power, and potentiality. Such is the nature of Sacred Idolatry, and of occult images.

5

RESTORATION: TOWARD SACRED IDOLATRY

FOLKLORE OF THE British Isles, as well as elsewhere in many lands, relates that the elder race of earth-dwelling spirits, the Faerie or Good Folk of Elphame, have from the most ancient times taken offense at the presence of iron. The presence of the taboo against ferrous metals is widespread in customs of plant-gathering and herb-magic, and has passed into various magical customs of spirit-conjuration, enchantment, and folk medicine. Like the calamity of faerie-haunting itself, the matter of iron taboo in magic is regarded so gravely in some contexts that its very presence is sufficient to abrogate the power of magic.

Whether this persistent teaching arises from belief or knowledge, it has direct implications for traditions of magical image-making, particularly since these precepts have filtered into witchcraft lore. In my own practice as an herbalist, certain traditional operations, as I have learned them, specifically require use of the bronze knife and pot, but the options for obtaining these when they were required were unacceptable to me. Through

the guidance of dream, spirit-patrons, and the turn of Old Providence, I undertook apprenticeship in bronze foundry in early 2005 with the intent that items be made by my own hands, and in dedication to the powers they would serve.[38] More than simply a means to an end, this act assumed responsibility for my own practice, and in essence 'cast myself anew' through the *wyrd* of the foundry. Much like the aspirant who stands at the edge of the Witches' Circle, as a novitiate of bronze I was subject to the instruction and transmission of a Master and Mistress, broken and made anew by the fires of the gods. As a means of offering myself to the Work of Image-making, such was the sacrifice required, but also resonant with what had come before: the Gods of Shaping are no strangers to witchcraft.

The Biblical figure of Tubal-Cain, the 'first instructor in every artifice of brass and iron', and a descendant of Cain, has come to a role of prominence within certain convocations of Traditional Witchcraft. Within the Sabbatic Current, the historical route of his entrance into the Craft is likely through both Freemasonry and smithing-guilds, but, more recently, through Romany-Chovihani teachings concerning the figure of 'Old Tubalo'. As the earthly son of Lamech the Hunter, he is seen to preside over the art and artifice of metal; as the descendant of Cain, he embodies the inheritance of transgressive Fire

38 I am also indebted to my colleague Soror S.I., who provided encouragement and support in this endeavor.

of the Art Magical. In his Draconian aspect of Tubalo-
Lucifer, he is the conduit of celestial fire, the shaper of
the Adept in the Forge of Initiation, and the Arcanum of
the Herald of the Dawn.

My foundry work has had a profound effect upon my
experience of these ancient powers, allowing the under-
standing of craftsmanship to augment magical power.
Through the vehicula of metal and fire, the crucible and
the forge, the Presence of the Spirit of Metal assumes
dimensions beyond those previously understood. In ad-
dition, the wisdom-teachings of Old Tubalo have deep-
ened my active knowledge of the metallurgic aspects of
Alchemy, which I have long studied.

Sacred Idolatry, or attainment of inner gnosis
through sensorial communion with outward form, har-
nesses at once the tri-form sorcerous moduli of Ingress,
Egress and Congress; it achieves this by the unifying the
gemini of Embodiment and Transcendence. The Fasci-
num of Sensorial Congress becomes a unitive enchant-
ment, transcending the dual nature of Self and Other.
In this wise, Self is to Other as Idol is to God; together
the dyads form what Giordano Bruno calls 'The Living
Mirror', and what the Witch calls the Plot or Field of
Art. Containing all things, this Field is fixed in its state
of being all-giving, but is also suggestible, as it contains
the shadows of all things. The Living Idol is thus the
correctly-rendered fleshing of Divine Void; the Sum of
Entity infinite, and the Mask of Entity finite.

As with perception and veneration, the reification of witching-images muſt of necessity occur within the Circle of Art, whether such takes place in solitary worship, or in the High Sabbat itself with many congregants present. Origination of such objects and images is ecſtatic; their purpose ultimately votary, Gnoſtic, or thaumaturgic. Each image conceived within this crucible is indeed become the literal embodiment of a spirit, spell, or other magical formulation, but also a temporal record of that diablerie which has transpired.

To the adept of the Sabbatic Myſteries, the *Imago* muſt transcend exclusively visual sensoria; all organs of sense may thus fun ion magically as "eyes". Thus the Arena of Reception, which serves as the conjured Field of the Sabbath, is comprised not only of the Eye, but also the Hand, Mouth, Phallus, Kteis, and other diverse anatomical gateways.[39] The living skull in particular is venerated as the Temple of Dreaming, and as a point of ingress-egress of the spirit.

These occult *principia* give rise to a different manner of "Seeing", wherein the Eye functions not only as the gateway of visual phenomena but as the sexualized extension of the sorcerer's Will, interacting in congress

39 The five senses, as empowered magical intercessors, are referred to by Andrew Chumbley as 'Pathways of Mediation', stressing their liminal position between 'Self' and 'Other' and their function as gates allowing ingress and egress. Their applied unity is Telaesthesis. *The Azoëtia, A Grimoire of the Sabbatic Craft*, 224–227.

with the world. As expected, these expanded moduli of 'Sight' also expand the frontiers of Magical Aesthesis beyond the constraints of the Image to all of Nature. We are familiar with metaphors for keen eyesight such as 'a penetrating gaze', perhaps initially referencing the active component of what is otherwise considered a passive sense. But the ability of the Magical Eye to penetrate zones of power, and be penetrated by them, is also implied, and this sexual symbolism is especially relevant for the making of occult images. This has far-ranging implications for the initiate of Witch-Mystery, especially amid the metamorphic synesthesia of the Sabbat. Perhaps more than anything else, it reveals the Sexual Fascinum ever-present in perception, and thus redefines the Nature of the Beloved.

This ecstatic magical technique employs the medieval virtue of phantasie as the active, image-making imagination, and it assists in the three magical spheres of reception, veneration, and reification. From this perspective, mundane idolatry is worshipping a deity in visible form, and Sacred Idolatry the power and practice of venerating the divine in sensorial forms of all kinds, up to an including the act of Congress. This is not an argument for common sensualism; rather it is the living reality of the sorcerer who has hallowed all physical faculties in devotion to the Art Magical.

Given the importance of the Eye in image-making and veneration, the implications of religious condemnation of idolatry upon magical praxis are profound. Taken

to its logical conclusion, adherence to its law would require a person to be blinded: the Eye is the Vessel of all Image, and their reception is a conscious magical act. If we extend the magical act of 'seeing' to all sensorial gateways, one becomes constrained to those perfected temples of Denial: the cloister and convent.

To the sorcerer, no graven image offends a true god, save that which fails to convey power. This is the dead image, which, like the dead letter, obstructs the intercourse of spirit-unto-spirit via the corporeal sensorium. The world is not dead, save the Man of Clay make it so. Likewise, the senses deceive not, unless humanity empower them as deceivers.

MAKING PRAYER OF THE GRAVEN IMAGE

Heavenly force unto earthly form,
Blood-fire I call from the hallow'd height.
Earthly form unto heavenly force,
I raise my hand to the One of Light.
This Flesh once-hallow as the dawn-fire of Self;
This Holy Corpse rise anew
As Iron blood-red from the Forge of Midnight.
Fires of Offering I burn before thy hallow'd flesh,
To light the Banquet of Elder Worship,
Come forth in blessed substance,
Now receive the Heart's own sacrifice.

BIBLIOGRAPHY

Christian, William A. *Apparitions in Late Medieval and Renaissance Spain*. Princeton University Press, 1981.

Chumbley, Andrew D. *Azoëtia, A Grimoire of the Sabbatic Craft*, Xoanon 2002 (1992)

————— . *The Dragon-Book of Essex*. Xoanon, 1997 (2013).

————— . "Wisdom For the New Flesh" *Starfire* Vol. I, No. 5, December 1994.

Cornelison, Sally J. and Montgomery, Scott B., eds. *Images, Relics, and Devotional Practices in Medieval and renaissance Italy*. Arizona Center for Medieval and Renaissance Studies, 2005.

Godwin, Jocelyn. *The Pagan Dream of the Renaissance*. Phanes Press, 2002.

Idel, Moshe: *Golem: Jewish Magical and Mystical Traditions of the Artificial Anthropoid*. State University of New York Press, 1990.

Joralemon, Donald and Douglas Sharon. *Sorcery and Shamanism: Curanderos and Clients in Northern Peru*. University of Utah Press, 1993.

Merrifield, Ralph. *The Archaeology of Ritual and Magic*. New Amsterdam Books, 1987.

Rowlands, Alison. *Witchcra Narratives in Germany: Rothenburg 1561–1652*. Manchester University Press, 2003.

Ross, Anne. *Folklore of Wales*. Tempus Publishing, 2001.

Schulke, Daniel A. *Lux Haeresis*. Xoanon, 2011.

————— . "Anatomies of Shadow", *The Cauldron* 149, August 2013.

Seims, Melissa. "The Coven of Atho". *The Cauldron* 126 November 2007.

Spare, Austin Osman. *The Witches Sabbath*. Fulgur, 1992.

Wilby, Emma. *Cunning Folk and Familiar Spirits*. Sussex Academic Press, 2005.

The second edition of *IDOLATRY RESTOR'D*
was published by Three Hands Press April 2023.
It is comprised *in toto* of 2,500 perfect bound copies.

Scribæ Quo Mysterium Famulatur